This sketchbook belongs to

Ben Hugo Oswald

206-527- 7213

Text and art by Gilles Ronin
www.atelierdupelican.com

English adaptation by Mady Virgona
© Peter Pauper Press, Inc.

English cover design by Margaret Rubiano

Published in the United States by Peter Pauper Press, Inc.
202 Mamaroneck Avenue
White Plains, New York 10601
U.S.A.

Published in the United Kingdom and Europe by Peter Pauper Press, Inc.
c/o White Pebble International
Unit 2, Plot 11 Terminus Rd.
Chichester, West Sussex PO19 8TX, UK

Originally published by Dessain et Tolra/Larousse 2013 as *Carnet de Griffonnage*
Paris, Londres, New York
Copyright © May 2013
ISBN: 978-2-295-00445-1
Editorial director: Colette Hanicotte
Publisher: Corinne de Montalembert
Graphic design and layout: Florence Le Maux
Original cover design: Véronique Laporte
Production: Nicolas Schott
Original cover art: Dessin et Cie

ISBN 978-1-4413-1738-4
Manufactured for Peter Pauper Press, Inc.
Printed in China
7 6 5 4 3 2 1

Visit us at www.peterpauper.com

TAKE AN ARTISTIC JOURNEY

A light-hearted outlet for your thoughts, this little sketchbook travels with you and can be entrusted with your notes and doodles. Open it up and be immediately transported from Paris to London and from London to New York . . . perfect for sketching out your daydreams, discovering the intricate detail of New York's bright yellow taxicabs at the bottom of a page, practicing your perspective while staring up at Big Ben, reveling in the detail of a glass of Beaujolais nouveau, and bringing to life the muses surrounding Paris's famed Wallace fountains, if only in your mind!

Escape the shackles of daily stress and raise your spirits with new visual adventures.

PARIS • LONDON • NEW YORK

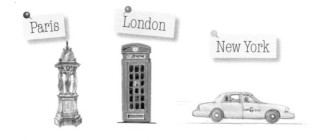

Paris

London

New York

Graphics, Values

A pencil draws lines. It is not meant to cover broad surfaces, as would a brush. Yet it can hint at vastness and create depth through shadow. It takes practice to "gray-in" areas with regular but varying values using dots or hatches. Start with a flat scene and then practice shading. Study the effects of varying the gaps between your lines. A gray area composed of fine, close lines can have the same value as another one made up of thick lines spaced farther apart. However, the brightness will differ. Another important element is the evenness of the shading. Short strokes are easier, but must be regular without resorting to mechanical rigidity.

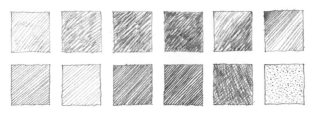

Try filling in some freehand squares with a variety of strokes, cross-hatching, tiny dots, and other effects. In general, shading will appear brighter if the white of the paper is visible between pencil strokes. Avoid "block" shading with continuous strokes.

LINE

In this case, "line" signifies a pencil stroke that is no longer interpreted solely as a graphic element, but rather as an interpretation, a pattern, a guideline, an outline, or an edging around a specific area. It is still a line, but different qualities are in play. Most importantly, one must learn to draw a straight line—by hand. A variety of methods are possible. The first consists of drawing very faint outlines which can then be traced over, all at once or a few at a time, while paying attention to line weights. The second consists of drawing several series of fine lines superimposed one over the other. The next level of line mastery involves the construction of shapes, and specifically circles (see the next page).

Control directionality: Begin with horizontal lines, then verticals. Next, continue with diagonals, paying specific attention to the angles they create.

To fill in an area with evenly spaced strokes, draw two parallel lines some distance apart, and then use increasingly close strokes to gradually divide the intervening space in half, then in half again, and so forth.

Draw lines with confidence: Draw two points some distance apart. To move from one to the other, keep your eyes on the destination point rather than the tip of the pencil. Make this movement twice; the first time, hover your pencil just above the paper.

CIRCLES

While this exercise is trickier, it is an indispensable skill to master, just like the square. Drawing progressively larger circles is excellent practice.

Construction lines should be used when increasing the diameter of a circle. The two vertical and horizontal axes marked will serve as primary aids. Make sure the circle touches the ends of the axes.

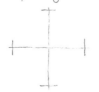 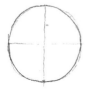 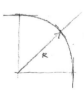

Frankfurter

Draw an ellipse with a slight upward
curve, taking care to lightly sketch
guidelines for each part of the hot dog.

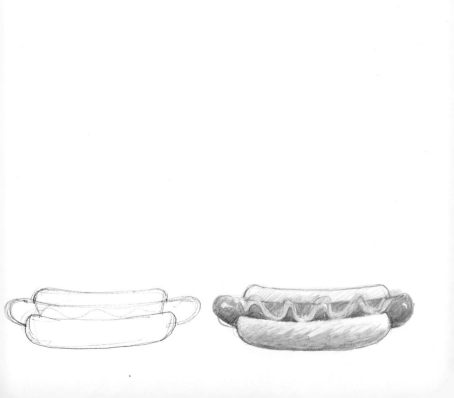

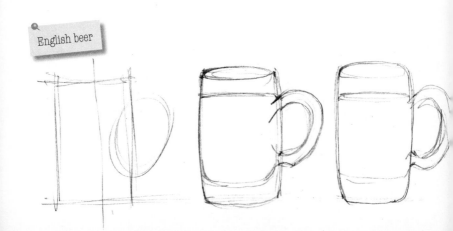

English beer

Blend the colors from nearly black
at the surface to increasingly bright
and light. Leave a white vertical band
along the side of the glass for the
reflection.

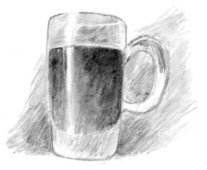

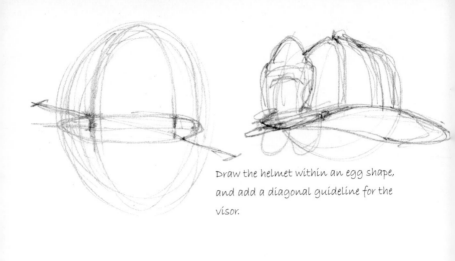

Draw the helmet within an egg shape, and add a diagonal guideline for the visor.

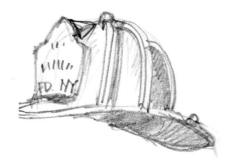

Firefighter helmet

The direction and length of the pencil
strokes add depth to the fur's texture.

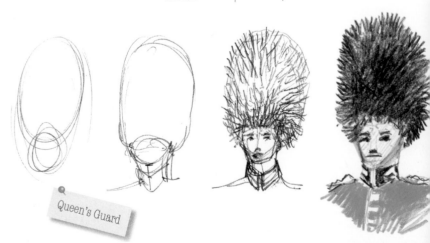

Queen's Guard

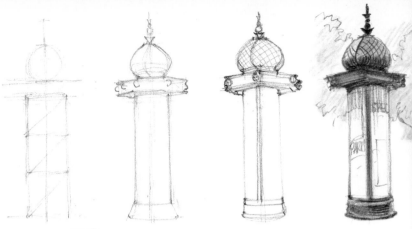

Morris column

Drawn within three stacked squares topped by a circle. The base of the dome overhangs the structure. Notice the opposing curves on the top and bottom of the column.

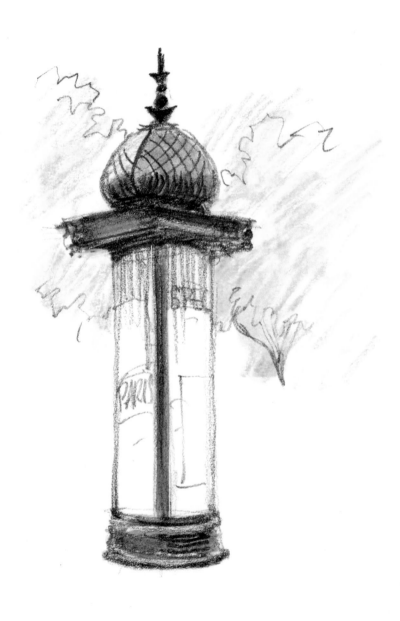

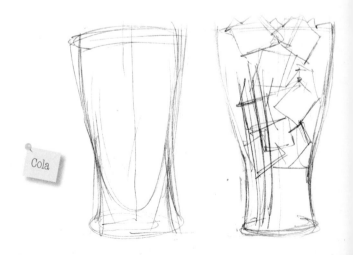

Cola

To create the lighter values of the
ice cubes, reserve several white areas
and accentuate them by darkening
adjacent areas.

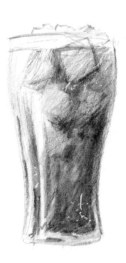

Baguette

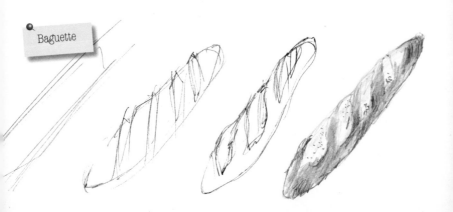

Boris Bike

Identify the various sets of lines—parallel or angled—in the bicycle frame.

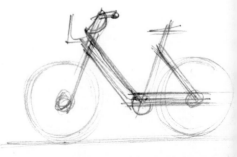

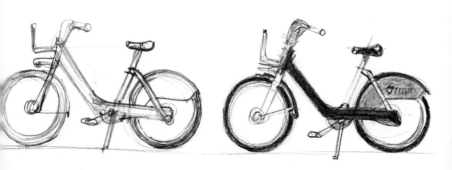

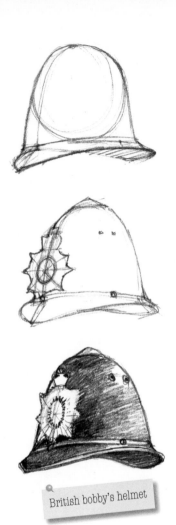

British bobby's helmet

Begin with a circle, under which
the visor will form a horizontal
figure-eight. Blend your shading
lightly for a matte black finish.

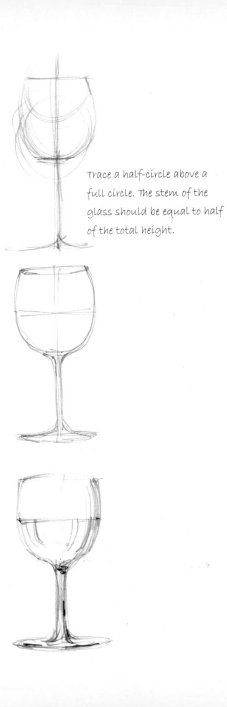

Trace a half-circle above a full circle. The stem of the glass should be equal to half of the total height.

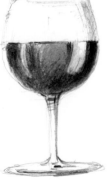

Wineglass

The wine in the glass bowl appears bright red, with very dark areas surrounding the white reflections.

Begin by shading in
the lightest area, which
should be a faint gray.

Bowler hat

Proportions

The critical element to understand in drawing is the notion of proportion. This has nothing to do with aesthetics or determining if the proportions of an object are pleasing or attractive; rather, this concept helps the artist properly reproduce subjects from real life.

HOW TO MEASURE PROPORTIONS

Make these measurements either by eye, or using the pencil as a measurement tool.

1. While grasping the pencil, extend your arm forward. Hold the pencil in front of a portion of the subject (the height of the roof, for example).

2. Using your thumb as a marker on the pencil's barrel, measure the short distance (a) between the top of the roof and the bottom. While this height bears no relation to your subject or the equivalent height in your drawing, it will serve as a unit of measurement. You can then compare other distances—like the width of the building—to the height of the roof.

3. While keeping your thumb on the pencil, move the pencil so that it covers a different part of your subject. Count the number of times (a) is contained in this new length by sliding the pencil over the required number of times— three times, in the example below, plus a remainder, noted as (R), which is slightly over one-half of length (a). Thus, the width of the building is 3.5 times the height of the roof. Between measurements, take particular care not to change the distance between your eye and the pencil, as this will lead to incorrect proportions.

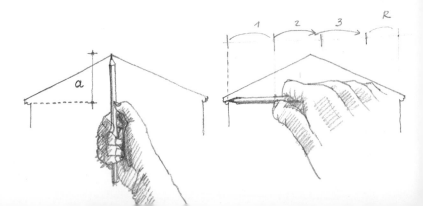

REPRESENTING PROPORTIONS ON PAPER

To draw the proportions demonstrated on the previous page, first sketch one of the lengths, preferably the shorter one (a shorter length is typically used to measure a longer one as it avoids the need for complex calculations). Measure three and one half times the shorter length, using the pencil and your thumb again or drawing faint marks along a line for calculation purposes. This creates the desired length.

FINDING THE CORRECT PROPORTIONS

The drawing will not have the same scale as your subject. Its only formal similarity with the subject will be in its correct proportions. This is where beginners often make serious mistakes.

More experienced artists occasionally fall into this trap as well. In fact, a drawing with absolutely flawless proportions would be essentially perfect. It is not the exact height of the object (for example, the 12-inch height of a bottle) that must be measured, but rather the angle at which we are viewing this object. Moreover, we are not even measuring the angle per se, but rather the relationship between two angles—in the example below, the angles from which we perceive the bottle's diameter and its height. It should be noted that the measurable "angle" refers to an apparent length, since perspective can change the relationship between actual lengths. In the end, it corresponds to what the eye sees in perspective.

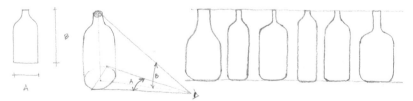

In the line of bottles above, notice how a similar shape takes on a completely different interpretation with each change in proportions.

1/3

Divide the height into
three parts. Then separate
the bottom third into two
equal parts.

1/3

1/6

1/6 1/6

1/6

Each leg goes through the center
of a square. Add the base arch as
a final step.

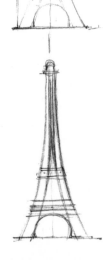

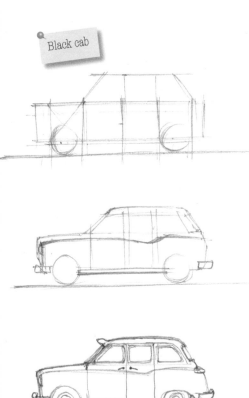

Black cab

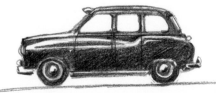

The glossy black cab body is rendered through white reflections on the upward-facing surfaces.

Parisian-style bike

Sketch the wheels and frame inside three equal squares.

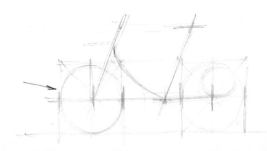

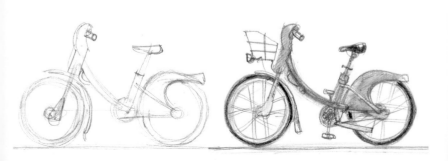

Outline all shapes inside a series
of spheres, then gradually flesh
them out with additional detail.

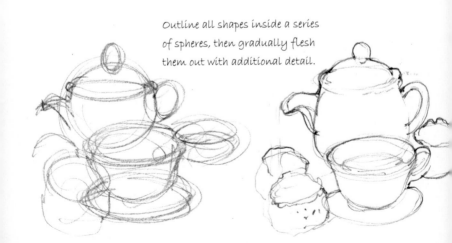

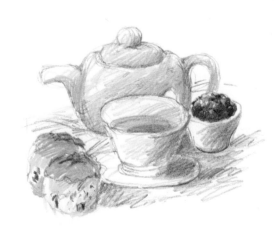

Tea and scones

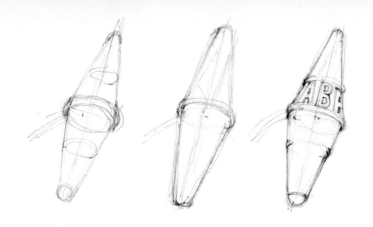

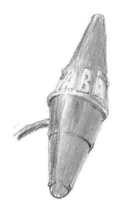

Create the "carrot" shape with two inverted cones seen from below. It's important to properly highlight the direction of the curve in the middle.

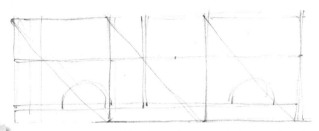

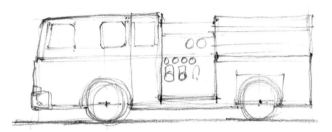

Fire truck

Begin with three identical, slightly vertical rectangles. The central portion of the truck only occupies 2/3 of the middle rectangle. Notice the different wheel positions relative to each square.

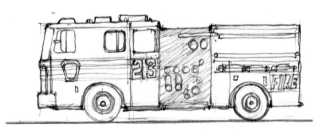

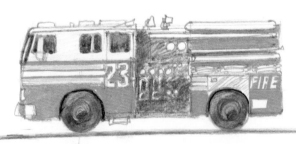

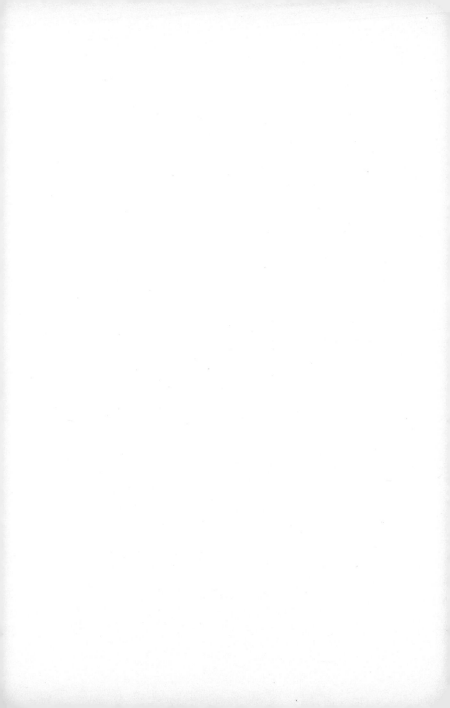

Beginning with circles and
ellipses, gradually establish the
shape of the cup and its saucer.

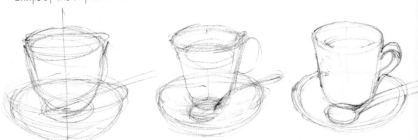

Coffee

The play of light and reflection
will vary based on the subject: the
coffee, cup, or spoon.

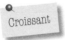

Croissant

Suggest the pastry's flaky
texture through individual
pencil strokes along the curve.

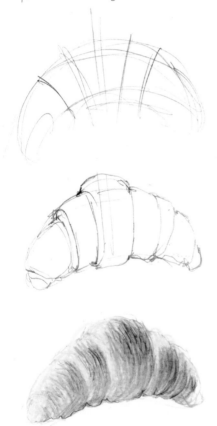

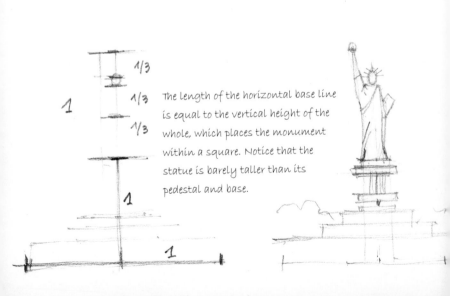

The length of the horizontal base line is equal to the vertical height of the whole, which places the monument within a square. Notice that the statue is barely taller than its pedestal and base.

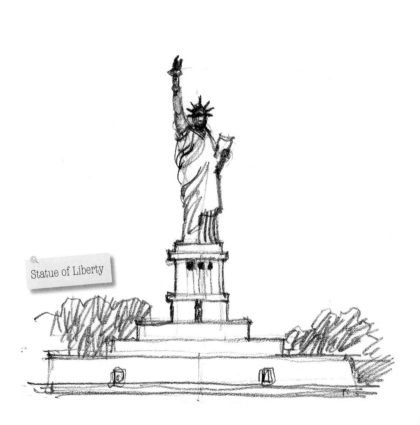

Statue of Liberty

ABBEY
ROAD NW8
CITY OF WESTMINSTER

**ABBEY
ROAD NW8**

CITY OF WESTMINSTER

Measure out spaces for each letter.

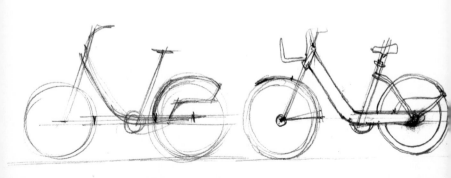

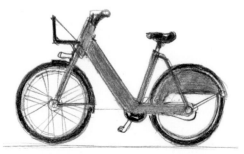

Citi Bike

Notice the rather massive frame
and robust overall proportions.

DIVIDING SPACE

Artists are frequently required to make simple length divisions. To do so, begin with a line or rectangle, and then use the intersection of various diagonals.

Dividing into 2: To divide a line, estimate its center point. To divide a rectangle, draw a pair of diagonal lines connecting opposite corners. They will intersect at the center of the rectangle.

Dividing into 2, in perspective

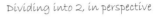

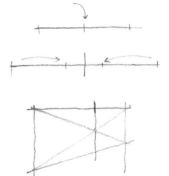

Dividing into 3: Use your best guess to divide the line. Do the same with a rectangle, or use the diagonal method.

Dividing into 4: Divide in 2, twice.

Dividing into 5: Use your best guess to divide the line, and then repeat. Set aside a central area, estimating that the two remaining sections are double the size of this space. This is fairly straightforward. Cut these remaining sections in half.

Dividing into 6: Divide into 3, then into 2. You may also do the reverse, but it's easier to begin with the division that creates visually smaller intervals.

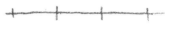

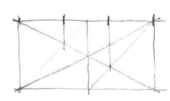

Dividing into 7: Apply the same principle as dividing into 5, i.e. setting aside a central area and then dividing each side into 3 equal parts.

Dividing into 8: Halve 3 times.

Dividing into 9: Divide into 3, 3 times.

Dividing into 10: Divide into 5, and then halve each segment.

What about dividing into 11? This is a fairly rare instance that requires Thales' Theorem.

DIVIDING WITH THALES' THEOREM

We wish to divide a line (segment AB) into a number (N) of equal sections. In this example, N=5.

Beginning at A, draw an auxiliary line (AX) of undefined length (the angle is not important). From point A, trace a short segment (a). Repeat the process five consecutive times along the AX line. At this time, you arrive at point C. Next, draw a line from C to B (CB) and a series of parallel lines to CB for each previously–identified segment, as shown on the drawing. This results in the desired division. Thus, we have replaced a division of space by a series of additions and the creation of parallels. Using this method, any segment can be divided into any number of equal parts; the higher the divisor, the more interesting the construction.

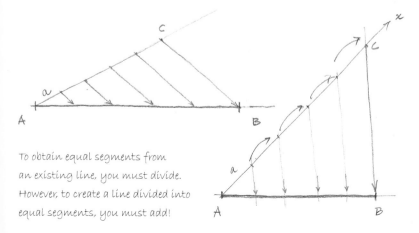

To obtain equal segments from an existing line, you must divide. However, to create a line divided into equal segments, you must add!

The general proportions
are created by stacking
three squares.

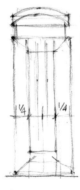

Divide the inner rectangle
in seven to get the height
of the vertical strips.

¼ ¼

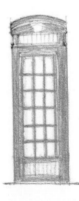

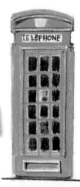

Telephone booth

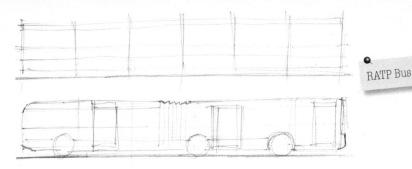

Begin with six lightly-sketched squares, and then position the wheels, doors, and central section of the articulated bus.

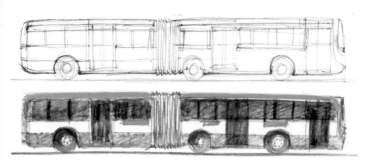

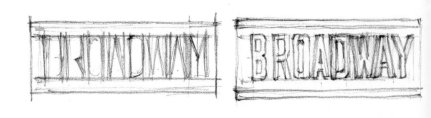

BROADWAY

Broadway

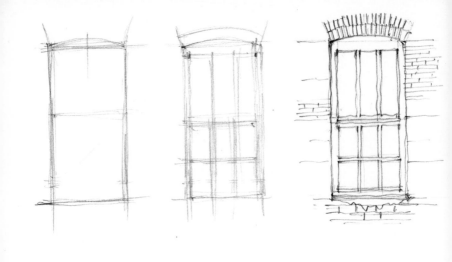

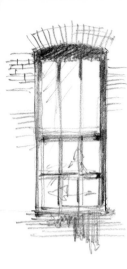

Window

The overall proportions are composed of two squares overlaid with a wooden frame and topped by a small brick arch.

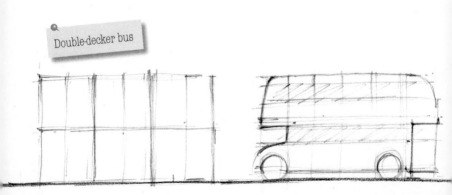

Double-decker bus

The light shadowing that frames the windows
adds depth to the interior space.

Empire State Building

The vertical balance of space is vital. Make sure to differentiate the base, body, and top of the building.

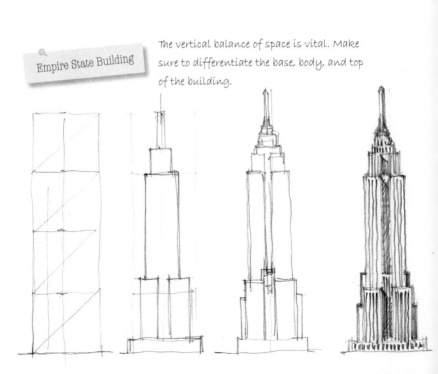

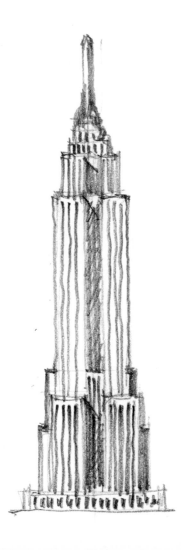

Create the façade from a circle overlaid
by two towers, each occupying 1/3 of the
exterior space. Divide the height of the
cathedral into three equal bands.

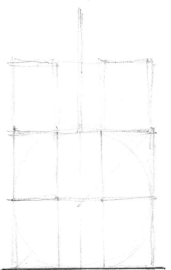

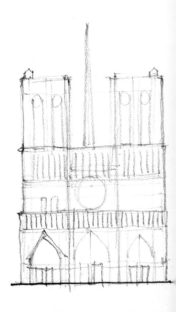

Notre Dame

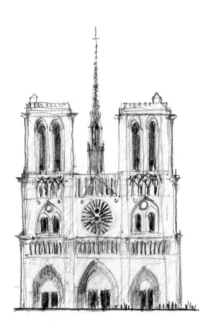

Sketch an ellipse above the dome as a guideline for the tops of the 12 yellow masts (of which only 11 are visible in the drawing), which form a crown.

Millennium Dome

Perspective

Perspective can be created with instruments such as T-squares and rulers. However, our goal is to learn it freehand. This requires practice in finding views and angles that are appealing. Provided the result looks consistent, these instructions do not need to be followed to the letter.

AVOID THIS COMMON MISTAKE

When you begin drawing a cube in one-point perspective, ensure that the farthest and nearest corners (A and B) do not lie along the same vertical. Doing so creates superpositional issues; these can cause problems in executing your drawing and ensuring it is interpreted correctly. This common problem can crop up often if you are not careful.

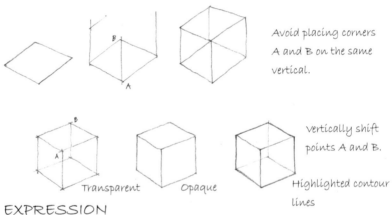

Avoid placing corners A and B on the same vertical.

Vertically shift points A and B.

Highlighted contour lines

EXPRESSION

Practice these exercises to identify different ways of rendering a cube— transparent, opaque, strong contour lines, etc.—and different shading methods. Find a style and repeat with some regularity, but leave room for slight variations.

Undefined edges

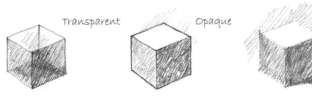

THE "MAGICUBE"

Hollow out a cube comprised of eight smaller cubes, so that only seven remain.

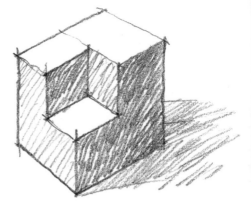

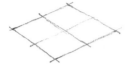

1. Begin by lightly sketching the base, and as always, divide it into four along the axes.

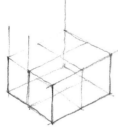

2. Raise the vertical guidelines to create the first level of small cubes.

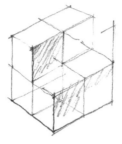

3. Move to the second level, continuing to sketch in the individual shapes.

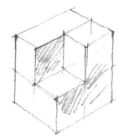

4. Ensure the pencil strokes and points align properly before marking in your lines.

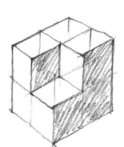

5. Complete the drawing by ensuring that the corners are accurate and the sides are properly defined.

Avoid "approximate" intersections like these!

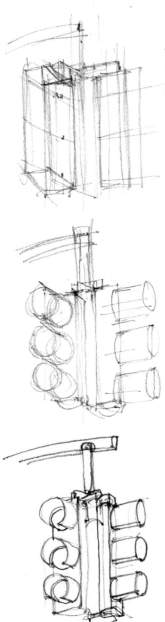

Begin with two vertical
rectangles tall enough to
contain three stacked circles.

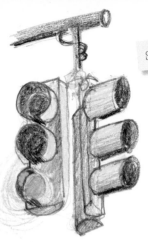

Suspended traffic light

Pay particular attention to the direction in
which the dome's lines curve, as opposed to
those in the base.

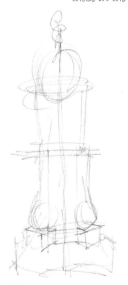
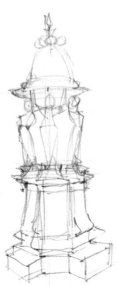
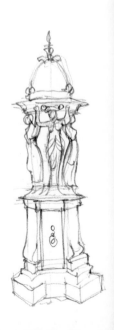

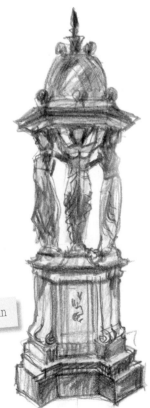

Wallace fountain

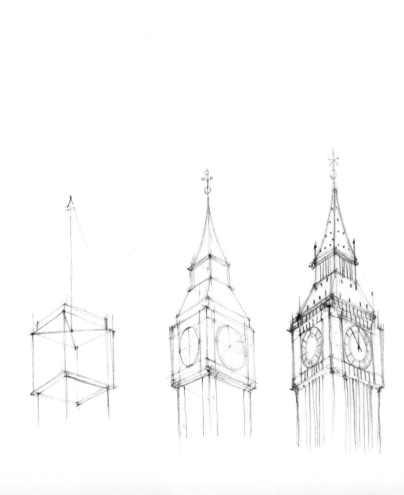

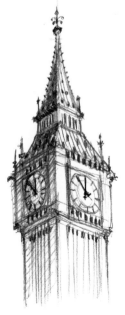

Big Ben

Essentially, this is a cube topped by
a very tall double pyramid.

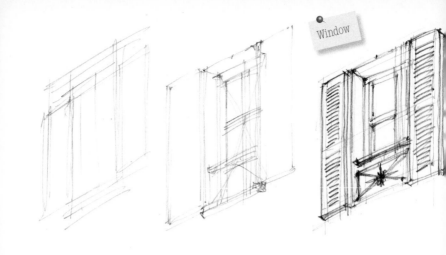

Window

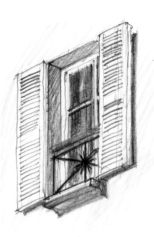

Draw a rectangle in perspective, then add a shutter on each side equal to half of the rectangle.

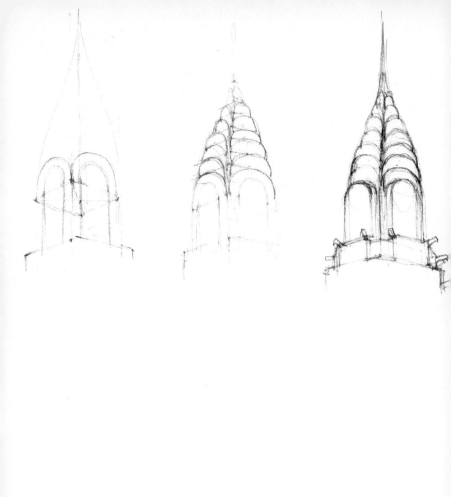

Draw a pyramid made up of successive nested circles, like fish scales, along the building's two visible sides.

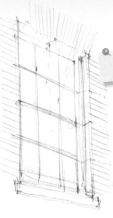

Sash window

Create depth in the window by staggering the shapes in the frame and mullions.

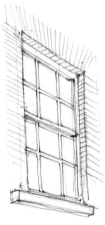

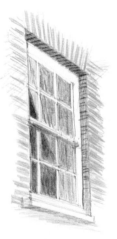

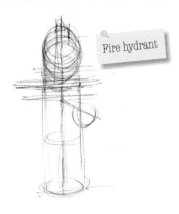

Fire hydrant

Use successive circles to represent the
hydrant's cylindrical arms.

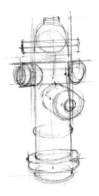

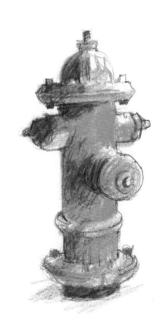

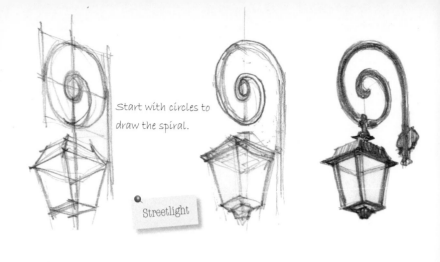

Start with circles to draw the spiral.

Streetlight

Stack two cubes and one cylindrical shape while
maintaining perspective.

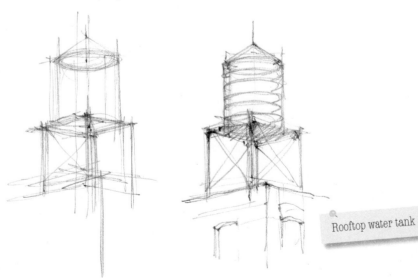

Rooftop water tank

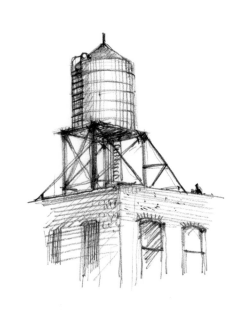

The Vanishing Point

The key to properly placing a vanishing point within a drawing is the ability to locate it within the field of vision. This ability is not tied to the drawing itself, but is an important skill to develop.

WHAT IS A VANISHING POINT?

If we observe straight parallel lines that recede from us, they appear to meet at an infinitely distant point. This is the vanishing point. The lines that lead the eye there are known as perspective lines. For the most

part, this phenomenon only occurs in architectural or urban environments; there, the plentiful lines created by rooftops and window frames run parallel to streets and roads in set directions. This is rarely seen in nature, where perspective is limited to the effects of distance on size.

PLACING A VANISHING POINT

Do not look only to one side. In general, one should be in a space with lines to the left and right, all moving in the same direction. Learn to look exactly in the direction of the lines, as though emitting a beam of light with your gaze. Notice any receding lines parallel to your line of sight in each direction, left and right, and even above you or on the ground, like floor tiles. Imagine aiming a bow and arrow in this direction, and place a target exactly at the center of all the lines. This is the vanishing point's position in the scene.

THE VANISHING POINT FOLLOWS YOU

If we move while continuing to look in the same direction (and keep our imaginary bow and arrow parallel to this direction), the vanishing point also moves within the landscape, and our arrow would not strike the same point. When we move, the vanishing point of the lines seems to move with us. The horizontal vanishing point appears to be at eye level. In the two drawings below, a person is visible. If we agree that he is directly opposite us, we notice that the vanishing point follows our vertical movement, and the defining characteristic is that he is precisely at eye level. This is an extremely important point to keep in mind when determining perspective in architecture or urban views, since most of the lines creating a vanishing point will be horizontal.

"TRUE" VERSUS VISIBLE VANISHING POINTS

The vanishing point is an imaginary point located at an infinite distance. This is known as the "true" vanishing point. Obviously, it is impossible for us to see all the way to this infinitely-distant point. The landscape will always be blocked by an obstacle; in the drawing below, this would be the building opposite us. Thus, our gaze moves parallel to the receding lines and converges to an end point known as the "visible" vanishing point. It is the visible vanishing point that we must properly place in our drawing.

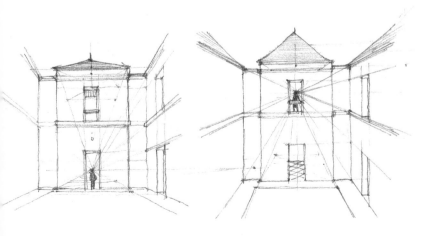

Notice that all of the building's horizontal lines touch the vanishing point of each street.

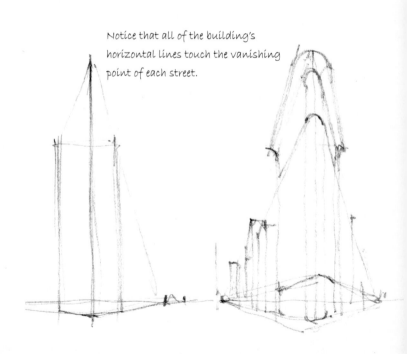

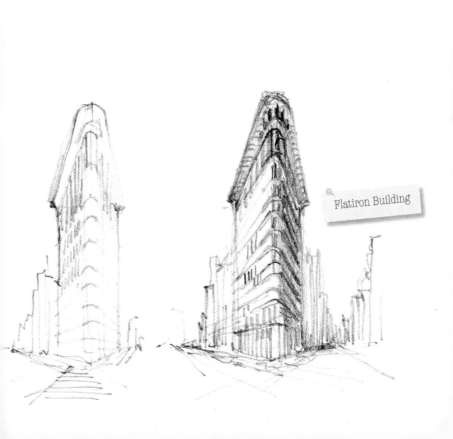

Flatiron Building

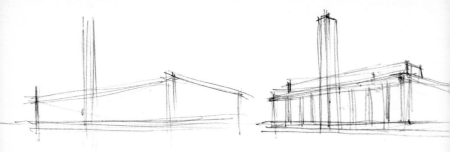

Begin by drawing a large box
shape in perspective. Next, divide
it vertically, placing the chimney
in the center and three wide
bands on each side.

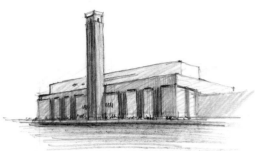

Tate Modern

Despite its curvature, the bridge's deck appears as a straight line that extends to its vanishing point.

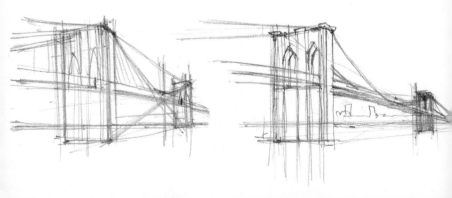

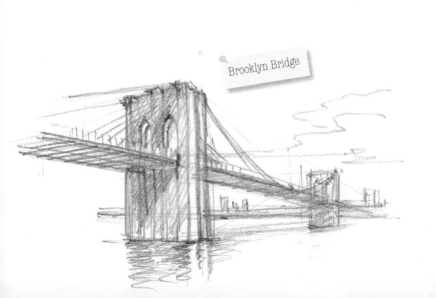

Brooklyn Bridge

The ribs of the glass canopy create a fan shape that originates from a point between the two rear pillars.

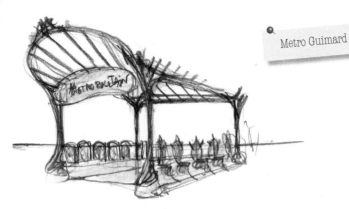

Metro Guimard

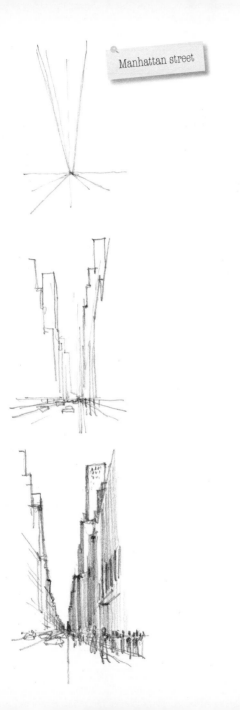

Manhattan street

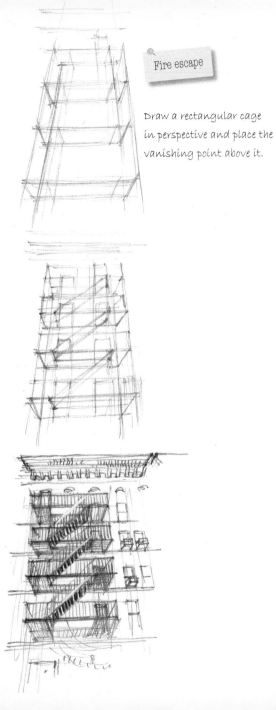

Fire escape

Draw a rectangular cage
in perspective and place the
vanishing point above it.

The Horizon

The perspective horizon is the line that connects all the vanishing points in every horizontal direction. Among all of the possible parallel lines, some are angled, while others are horizontal; in fact, most are either horizontal or vertical. Every direction generates a vanishing point. If we observe these vanishing points, they are aligned along a specific line. This line is the horizon. Naturally, it does not always appear, and is frequently hidden within the landscape. However, it should be added to every drawing as it constitutes the primary frame of reference for constructing perspective.

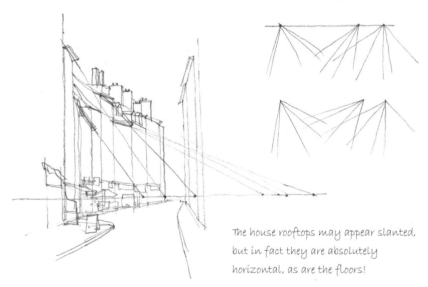

The house rooftops may appear slanted, but in fact they are absolutely horizontal, as are the floors!

WHERE TO PLACE THE HORIZON

As the vanishing point of horizontal lines is located at eye level, the horizon is also situated there. As a result, the horizon is also a subjective concept. To place the horizon, it is necessary to identify elements within the landscape that are located at eye level. As we observe an urban street scene, for instance, the heads of passersby across the street would be roughly at our eye level. We only need to connect them to identify the horizon. On a typical street, the horizon would be located on a level roughly equal to the middle of the storefront windows. However, beginners will often place it closer to the building's second story.

THE HORIZON IN DRAWING

The artist will choose the placement of the horizon in a drawing. It may be placed low to emphasize elements above the horizon (and above the artist) such as clouds or the sky. Conversely, the horizon may be placed high to emphasize elements below eye level.

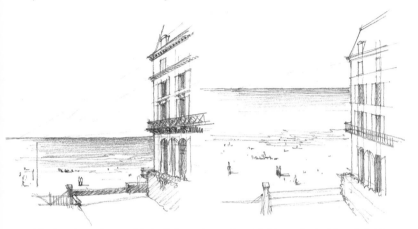

In this drawing of a seaside building, the height of the horizon is located just below the balcony above the first-floor windows. This provides implicit information about the height of the artist's location.

The artist has climbed to a height equal to the building's second floor. Since the horizon has also risen, more of the beach is visible.

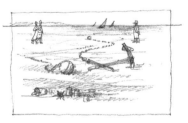

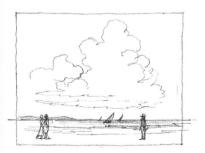

The artist has chosen the top part of the landscape (the sky and clouds) as the main subject of the drawing.

The artist has chosen the lower part of the landscape (strollers and the beach) as the main subject of the drawing. In both cases, the vanishing points are still on the horizon.

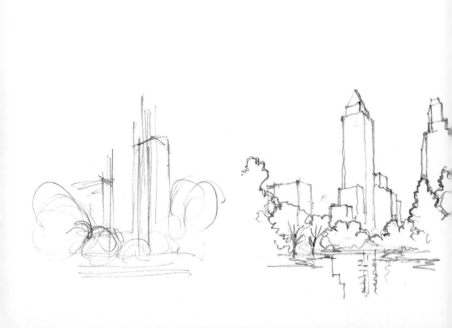

Mark the horizon by leaving a thin strip of white at the base of the tree line.

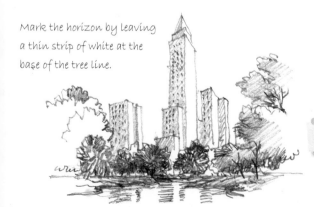

Central Park

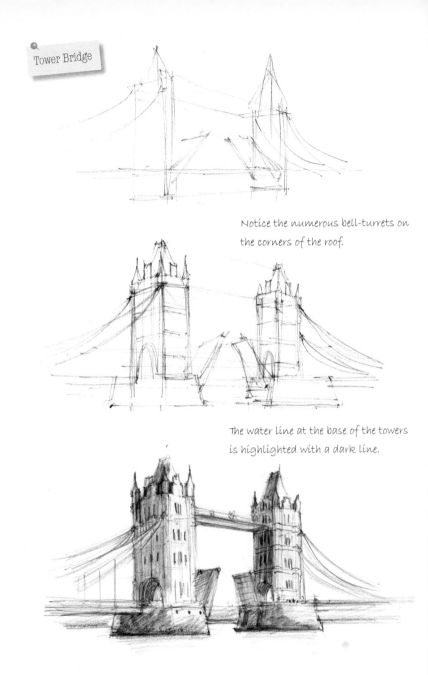

Tower Bridge

Notice the numerous bell-turrets on the corners of the roof.

The water line at the base of the towers is highlighted with a dark line.

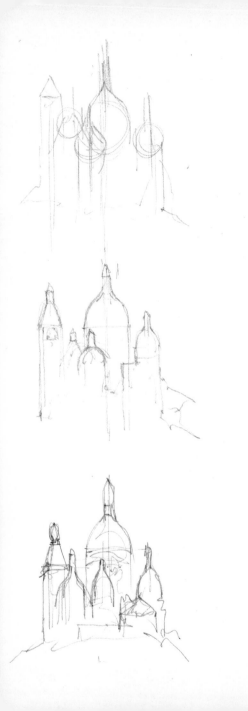

Emphasize the whiteness of the
architecture through even, dark
shading in the sky.

Sacré Coeur

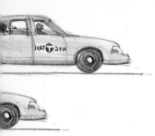

Emphasize the horizontal lines of the car's shape on the ground, and add movement to the overall coloring for a more dynamic feel.

Yellow taxi

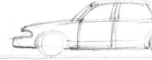

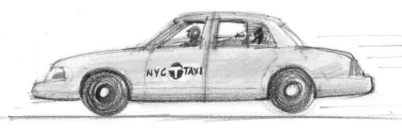

Draw the circle within a square in perspective;
this creates an ellipse.

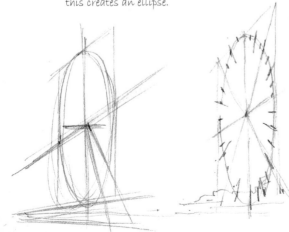
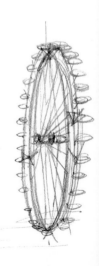

London Eye

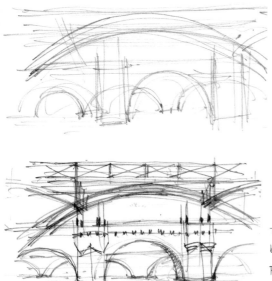

The perspective of these three bridges is created through progressively smaller arches drawn one inside the other.

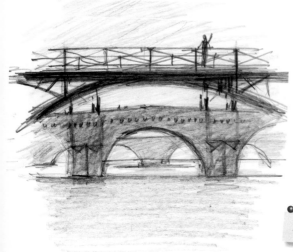

Parisian bridge

The building appears to float above the horizon, an effect created by the ground-floor shadows.

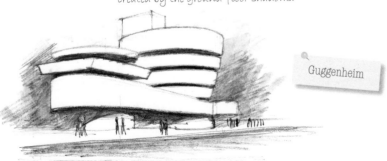

Guggenheim

Draw the four main lines, the shape
of the tower, and the windmill blades.
Next, sketch two angled parallel
guidelines for the text.

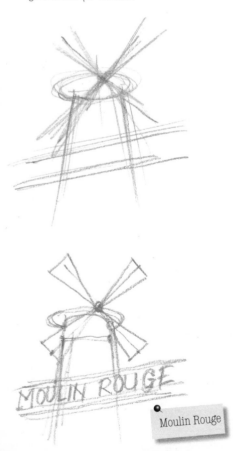

Moulin Rouge

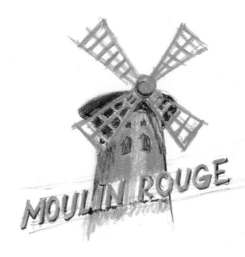

Travel Memories